Union Public Library
1980 Morris Avenue
Union, N.J. 07083

Draw Animals
with expression and personality

Anja Dahl

Draw Animals

with expression and personality

Union Public Library
1980 Morris Avenue
Union, N.J. 07083

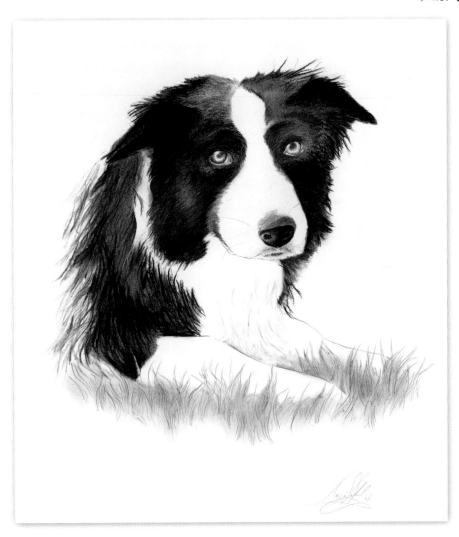

SEARCH PRESS

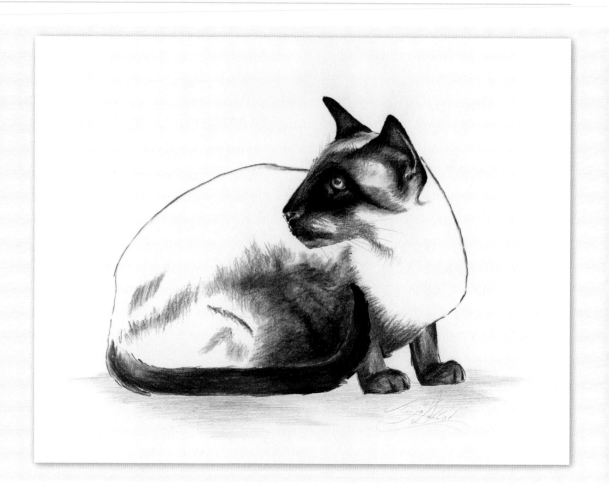

First published in Great Britain 2011 by Search Press Limited,
Wellwood, North Farm Road, Tunbridge Wells, Kent TN2 3DR

Originally published in Germany 2007 by Englisch Verlag GmbH, Wiesbaden as Workshop Zeichnen:
Tiere – Ausdruck und Persönlichkeit

Copyright © Englisch Verlag GmbH, Wiesbaden 2007

English translation by Cicero Translations

English edition typeset by GreenGate Publishing Services

All rights reserved. No part of this book, text, photographs or illustrations may be reproduced or
transmitted in any form or by any means by print, photoprint, microfilm, microfiche, photocopier,
internet or in any way known or as yet unknown, or stored in a retrieval system, without written
permission obtained beforehand from Search Press.

ISBN: 978-1-84448-695-3

Pictures provided by: page 22: private individual; page 42: M. Kleinow, www.adpic.de; page 45: L. Rößner;
all others: www.digitalstock.de
Production: Michael Feuerer
Printed in China

Contents

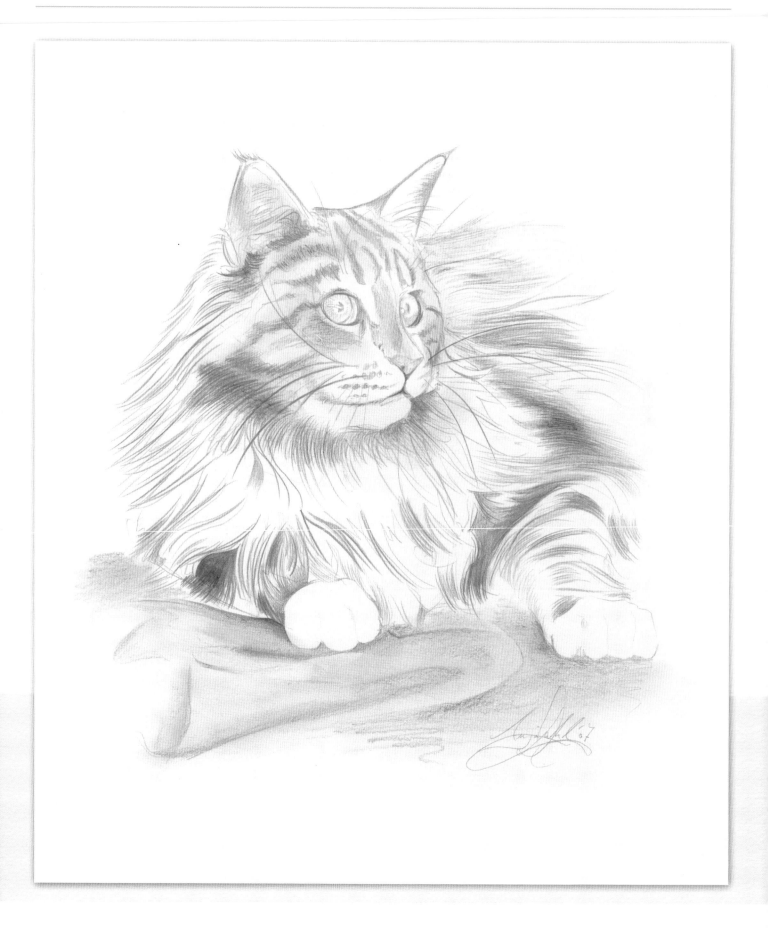

Foreword

An animal's face has definite characteristics, yet it is more difficult to portray these than those of a human face, even though they may appear simpler. The surface of human skin offers more scope for individual nuances, such as wrinkles and dimples, which give the face expression. Animals' faces are covered with fur or feathers and only the position and shape of the head and its features – the eyes, eyebrows, muzzle and ears – give the face of an animal its individual characteristic appearance. To capture an animal's expression and personality in a drawing is therefore not always easy. Often, it is only the subtle details that determine the essence of the animal.

It definitely helps to know the characteristics specific to the breed you are dealing with because you can start with this and then concentrate on the features of the particular animal you are drawing.

So this book considers the characteristics of different animals – dogs, cats, birds and horses – and then takes a closer look at the typical features of various popular breeds. This gives you the opportunity to build a more accurate picture of an animal before you start drawing.

In the section on basic principles, you will find information about drawing media that are particularly suitable for depicting fur and feathers and learn some simple techniques that you can apply.

I hope that this book will help you capture the character and personal expression of your favourite animal. I wish you lots of fun and success with your drawing!

Basic principles

Materials

A good starting point is a practical artists' set containing a selection of different drawing media, or you can buy pencils and chalks individually depending on what you need and feel most comfortable using. You will also require a sharpener and an eraser. A kneadable eraser can be used to erase without leaving any bits and it can also be shaped to a point to erase fine areas neatly. To prevent the drawing from slipping, use adhesive tape to stick the paper to the table or a board. A stump (paper blender), a sponge and a cotton cloth or paper tissue are recommended for accurate smudging. To protect your drawings, slip a piece of paper under your working hand to prevent accidental smudging while you draw and spray the finished works with spray fixative when you are satisfied that they are complete.

Pencil and graphite

Most techniques begin with drawing an outline using a standard or graphite pencil. These pencils can also be used for creating complete drawings full of nuance. Whereas a standard pencil has a wooden barrel, a graphite pencil is made exclusively from graphite and can therefore also be used for broader shading. Lead and graphite pencils come in various grades of hardness. For soft shading, harder leads are best, whereas strong shading needs soft leads. Sketching requires a harder pencil such as an HB. Start with the lightest strokes using hard leads and then change to darker strokes using softer leads.

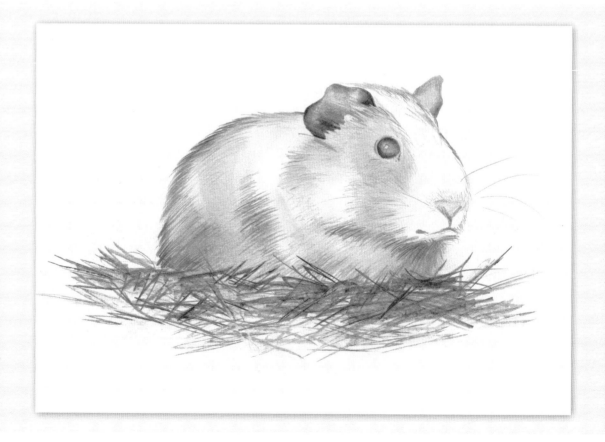

Pencils in different grades of hardness will produce different shades of light and dark in a pencil drawing. Soft transitions can be achieved by smudging.

Indian ink

Unlike pencil and graphite, Indian ink cannot be erased. You will therefore need to practise and plan in advance before you actually start to draw. You should work out in advance which areas of the sketch are going to be light or even left white and which will require darker shading. The depth of the shading depends on the density of the hatching. To make the introduction to using Indian ink easier, rather than using pen and ink for the practice picture, a Rapidograph technical pen is used instead, which has a fine, even nib and uses ink cartridges so that you do not have to worry about dipping the pen into the ink. A cloth or paper tissue should be used to wipe the nib of the pen.

Rapidograph This is a thin-nibbed Indian-ink cartridge pen that enables the drawing of a precise, constant line.

Experiment with your Rapidograph pen to produce different types of hatching and shading.

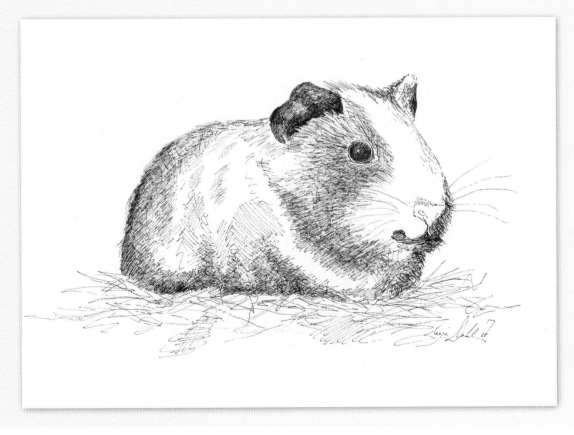

When drawing with Indian ink, areas of light and dark are indicated by varying the density of the hatching.

Light and dark sepia (top left and right), red chalk (bottom left) and charcoal (bottom right) are soft drawing media that are excellent for smudging.

Charcoal, red chalk and sepia pastel

Charcoal, red chalk and sepia pastel are the most traditional drawing media. They now come in pencil format with a wooden barrel and as sticks. They are very soft drawing media that therefore quickly produce broad strokes. To judge the strength of the lines, it is advisable to practise the strokes on a separate piece of paper. Whereas a pencil produces a fine and precise line, charcoal, red chalk and sepia pastel are capable of covering large areas with even tones, which can be smudged using your fingers, a sponge or a cloth. The finished drawings should be protected from further smudging using spray fixative.

Chalk pastels

Chalk pastels are a popular medium for quick sketches, as well as for finely worked drawings. They come in two grades of hardness and in various colours. Soft pastels are suitable for large areas and soft transitions, hard pastels are recommended for fine details and lines. Pastels are perfect for smudging with your fingers or with a stump (paper blender), sponge or cloth. Chalk pastels also come as pastel pencils with a wooden barrel and can be used for fine, precise lines. Pastel drawings should be protected with spray fixative when complete to prevent smudging.

By using different-coloured chalk pastels, subjects can be rendered in their natural colouring.

Techniques

Outlining

With any animal, the quick capture of your subject by drawing an outline is an important preparatory step for the actual drawing. Hold the pencil loosely in your hand and let the tip glide lightly over the paper. It is important to capture and comprehend the whole of the subject in the outline. You can make several quick outlines of individual details on one sheet. With an outline, the shading is initially drawn in using simple hatching. Next, work on the basic lines by drawing over them several times until the perfect shape is achieved.

Sketching

Before you can start the detailed work on a drawing you need to establish the basic shapes. The shapes should first be reduced to the essentials to represent the basic lines. These not only serve as a guideline, but also save on materials, which would otherwise be used up in various failed attempts. Sketching should be done with an HB pencil, held so that it runs over the paper with very little pressure. The lines can be lightened using a kneadable eraser to avoid them showing through later. If you are working with light pastel pencils or red chalk, you should use the lightest shade of the colour range for sketching rather than using a pencil, which could dirty the colours.

Outlining Capture a subject with simple strokes.

Outlining enables an animal to be captured quickly on paper and serves as a basis for the subsequent drawing.

Sketching Determine the shapes through the use of simplified basic lines.

When sketching, the subject should be reduced down to its basic forms.

Hatching Place lines parallel or crossing to produce different tones.

When drawing using Indian ink, hatching is the only way of shading.

Hatching

Hatching means covering flat areas using lots of closely packed lines. These can run parallel or cross over each other to achieve a more intense darkening. Hatching is used on a pen-and-ink drawing, for example to achieve different tones. With a pen-and-ink drawing, this technique is the only method of shading other than completely blacking out an area. When outlining, hatching serves to depict shading quickly and easily.

Smudging Rub or wipe soft colour to create soft tonal transitions.

Soft transitions can be created by hatching and then smudging.

Smudging

To create soft transitions or delicate shading or to indicate shiny, soft fur, you can smudge hatched areas made with a soft drawing medium such as pastel by using your finger or a stump (paper blender). To increase this effect even more, light reflections can then be added using light chalk pastels that can also be lightly smudged. When using chalk pastels, final fixing is important to avoid spoiling the drawing by accidentally smudging it.

Converting shapes to a flat surface

Converting a three-dimensional subject on to a two-dimensional surface is not very difficult. Look for the basic shapes, such as squares, triangles and circles. The body of a bird, for example, can be formed from two ovals placed one above the other. The wings and the tail run into a triangle. Forming the subject from simple basic shapes makes the drawing process easier.

Use photographs as references to help you practise this process of simplification using basic geometric shapes. Outline the basic shapes to clarify them. With a little practice, this approach will become easier.

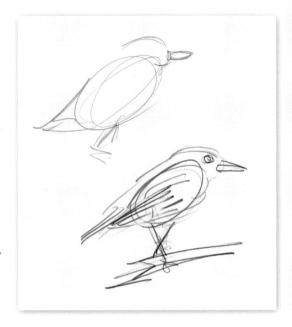

Converting the subject into its basic shapes makes it easier to draw.

A bird consists of two ovals and the triangles of the bird's tail and beak.

Conveying personality and expression

The longer you know an animal, the more of its personal characteristics you will notice. The individual traits give the animal a distinctive and also visible personality. Yet it is not always easy to replicate these when drawing. As with people, animals have certain fixed points on their faces that you need to consider first of all. Start by trying to work out the effect the eyes have on you. Do they appear wide awake, sad, tired or proud? Of course, facial expressions change frequently, but is there a particular expression that predominates? The position of the ears often emphasises this even more. As you separate out each part of the face and consider its characteristics, you will make it easier to reproduce the features in the drawing. It is always best to start with the overall shape of the head and then position the eyes, without

going into the detailed shape. Next, locate the nose at the correct distance from the eyes and chin and lastly work on the ears. Once all the parts of the face have been drawn in the correct relationship to each other, you can start to add the details.

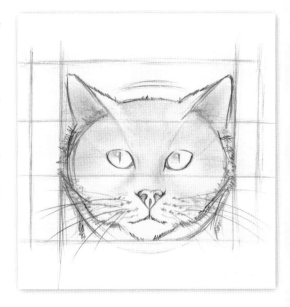

The individual parts of the face must be studied separately to capture an animal's characteristic expression.

Depicting fur and feathers

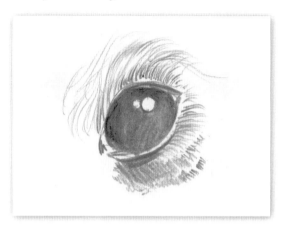

Above the eye, the fur grows upwards and to the side.

When drawing an animal portrait, the fur or feathers on the face are the most important. The direction of hair growth or the arrangement of the feathers should be reproduced when drawing. Above the eye, fur grows upwards and to the side. This applies to dogs, cats and horses too. Around the nose, the hair flows to the outer edge of the head and from the midline upwards. On the chin of an animal, the hair grows forwards and downwards. With birds, the feathers generally lie flat on the top of the head in a semicircle arranged from the front to the back. The feathers are finest and softest on the face and belly, which is why soft transitions should be indicated here through shading.

Small, fine hairs grow upwards on the bridge of the nose and to the side along the cheeks; on the chin they grow forwards and downwards.

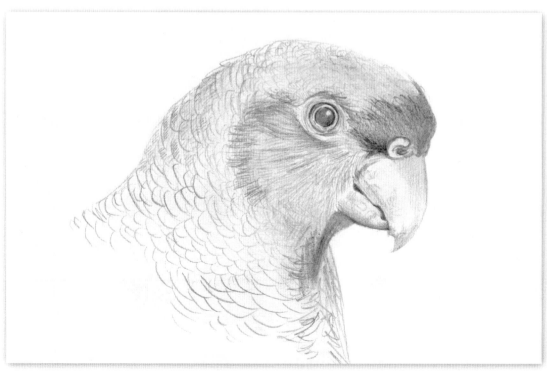

With birds, the feathers lie flat on the head and are arranged in a semicircle from front to back.

The texture of the fur is usually drawn with wavy, parallel lines, depending on the length. It is very important to work in some light reflections and draw strands in different intensities. It is best to draw long fur using a pencil; individual hairs can be depicted using fine lines or hatching. If you want to portray velvety fur, you can achieve this by smudging the texture of the fur, whether you are working with pastel, charcoal, red chalk or pencil. Then draw in some fine lines to give the drawing more of a three-dimensional effect, with the fur appearing thicker and with greater volume.

Draw strands of hair in varying intensity to indicate the light reflections.

Depicting velvety fur:
1 Apply colour.
2 Smudge the pencil strokes.
3 Draw or hatch over the top.

Drawing different kinds of animals

Lesson 1: dogs

Learning goal
Learn how to draw
portraits of dogs using
different drawing
techniques and working
on the typical features of
certain breeds.

When creating a good portrait drawing, it is particularly important to portray individual charisma. Every animal has a certain effect, especially on its owner. When you have had a dog for years, you know its personality, but it is not so easy to capture this in a picture. The right technique and an eye for what is important are crucial. First of all, you should view your dog quite objectively and only then include your own personal impression. If, before you start drawing, you separate out the typical features of the breed of dog, you can later dedicate yourself completely to the characteristic features of your pet.

Eyes, ears and muzzle

Most dogs have dark, expressive eyes. The expression of the eyes is also determined by the way the head is held. For so-called 'puppy-dog eyes', the head is hung and tilted to the side with the eyes large and round. The ears also contribute to the dog's expression. Watchful dogs prick up their ears, whereas, if they are tired and relaxed, their ears flop down. There are very many different shapes of ears, which is why you should pay particular attention to them. Dogs' muzzles, however, do not generally differ quite so much from breed to breed – they are merely different in terms of size or taper to be flatter or more pointed – although there are some exceptions.

You can read a dog's mood really well from its eyes and ears.

Body construction and proportions

Different breeds of dogs differ visually in terms of their size, build, type of fur and the shape of their head, ears and tail. These differences are especially clear in the profile view. A Border Terrier, for example, is small and dainty and has a relatively short back, whereas a Labrador has a stockier and more solid appearance. An Irish Setter on the other hand, has a long, sleek body.

Even the fur differs from breed to breed. The fur of a Border Terrier is rather short and bristly; a Labrador's is very short and smooth, whereas an Irish Setter's hair is longer, thicker and more lustrous. The shape of the tail is obviously different between these three example breeds too. It is therefore important to capture these features when sketching. It is best to draw some quick sketches first to work on these breed characteristics, before starting with the actual drawing.

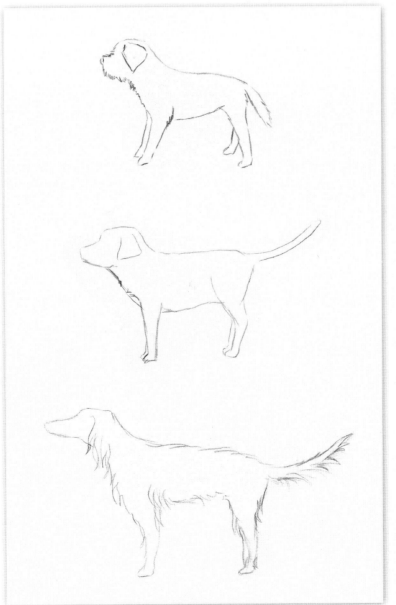

Border Terrier

Labrador

Irish Setter

The sketched profiles clearly show the different proportions of dogs of different breeds.

Border Collie

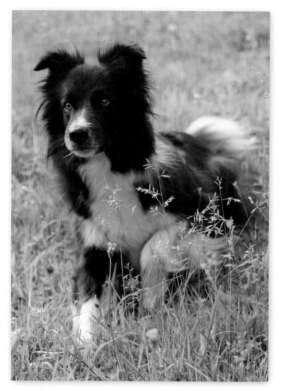

The body of a Border Collie is longer than it is high, and it is relatively muscular, as it is designed for rapid movement and stamina. The fur is fairly long and thick with a dense undercoat and a striking mane at the neck. The face and ears, as well as the fore and hind legs from the joint have smooth fur. The typical colouring is black and white, with black predominating, running out to white around the nose, over the forehead to the back of the head and around the neck like a white collar. There is a distinctive white tip on the tail. The head is broad with a pronounced muzzle. The eyes are medium-sized, as are the ears, the latter standing upright or tipped slightly forwards.

Distinguishing characteristics

+ The body is slim and athletic.
+ The head is square-shaped from the front because of the ears.
+ The ears are medium-sized and hang slightly forwards.

Technique tip

Due to the high black content of the fur, charcoal or black pastel is a good option for drawing a Border Collie. If you go over the large black areas with a thin white pastel pencil and fine hatching after fixing, you'll achieve a very good texture for the fur.

Step-by-step practice picture: Border Collie

1 Start by securing the paper to your drawing board or table using masking tape so that it will not slip while you are working. Using an HB graphite pencil and a few simple strokes, draw the outline of the Border Collie. When making the initial sketch, take care not to press too hard with the point of the pencil, otherwise, the deep grooves can cause white areas to be visible later. The shape of the head of the Border Collie is fairly square. The ears are slightly concealed by the long fur and fall forwards. The dog's eyes are round and medium-sized.

Materials required
- *Drawing paper*
- *Masking tape*
- *HB graphite pencil*
- *Black and white chalk (soft) pastels*
- *White pastel pencil*
- *Light sepia pencil*
- *Charcoal pencil*
- *Masking tape*
- *Kneadable eraser*
- *Thin stump (paper blender)*
- *Fixative*

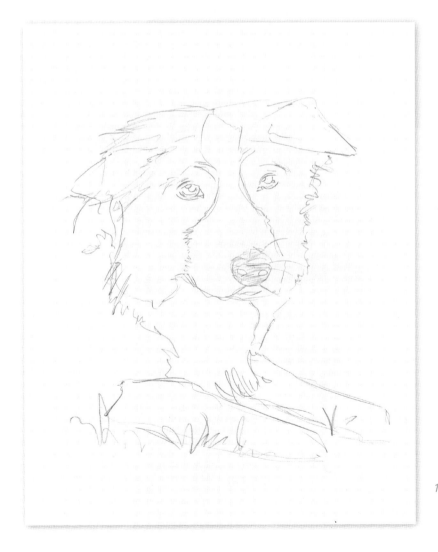

1 Sketch the dog's head using a few exploratory strokes.

2 Now blacken a large part of the drawing using the black chalk pastel. Run the pastel flat over the paper and use very little pressure. Smudge the applied colour carefully and evenly with your fingers. When smudging, take care not to work right up to the edge of the black drawing, as this area will be worked on again later both with charcoal pencil and with the white chalk. The eyes should be left blank, as they will be drawn later using charcoal. Spray the drawing with fixative spray to protect it from smudging while further work is done. Allow the paper to dry thoroughly.

3 Take the charcoal pencil and use it to work on the eye area. Use the pencil sparingly so that you can then blend it with a thin stump to form the fine contours of the eyes. A narrow white strip should be visible on the dog's lower lid, which can be emphasised using a little white chalk. Now fill the white edges previously left around the outline of the dog with a fine fur texture, alternating the white pastel pencil, the sepia pencil and the charcoal pencil. Add further hair to the body of the dog, making sure that the pencils are always sharpened to create the thinnest strokes. Add the grass and then fix the picture one last time.

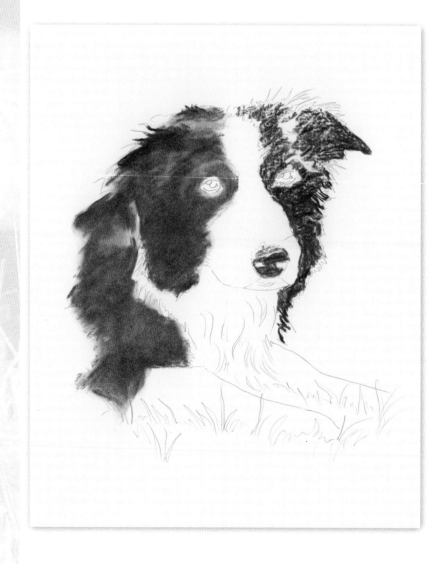

2 *Fill in the black areas with black pastel and smudge the marks, without going right up to the edges.*

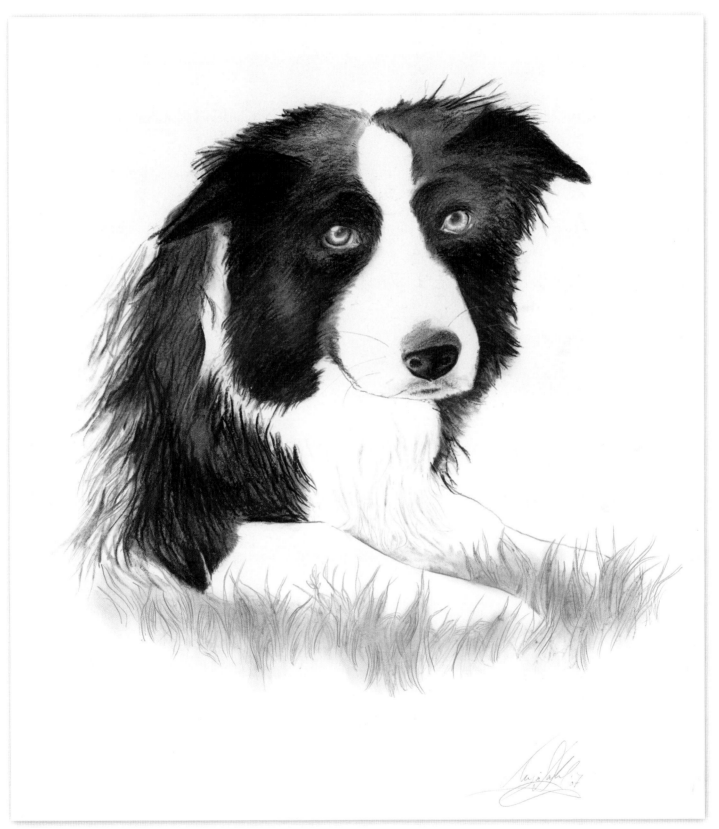

3 Develop the drawing, working on the texture of the fur around the outlines using a white pastel pencil, a sepia pencil and a charcoal pencil.

Border Terrier

The Border Terrier is a hunting dog that can be up to 30cm (12in) high. It has a thick, wiry coat that can have a reddish tinge with shades of wheat and grey. The head has a rather square shape from the front view, but this varies from animal to animal. The ears, which flop down, are small and stand away from the head a little. The Border Terrier's tail is very short and its body construction is athletic despite its small size. The muzzle is long and covered in coarse bristles.

Distinguishing characteristics

- The body is small but athletic with thin legs and a short tail.
- The head is square-shaped from the front view.
- The muzzle is long and the ears stand away slightly from the head.

Technique tip

Light pastel pencils and graphite pencils work well blended together to create a Border Terrier's fur. However, the pastel pencils should only be used sparingly. This will give a colourful texture to the fur with a three-dimensional effect.

Step-by-step practice picture: Border Terrier

1 This practice picture is worked using very reduced, yet sweeping lines. Quickly sketch the subject using a 6B graphite pencil with a sweeping flow of lines. This is important. Keep sharpening the graphite pencil otherwise the lines will be too broad. Only the ear and the collar are drawn using solid lines. The muzzle of the Border Terrier appears a bit wider due to the thickly drawn fur. Around the throat, the hair is slightly bristly. The Terrier's eye is round with the lid stroke running outwards.

Materials required
+ *Drawing paper*
+ *Masking tape*
+ *HB and 6B graphite pencils*
+ *Kneadable eraser*

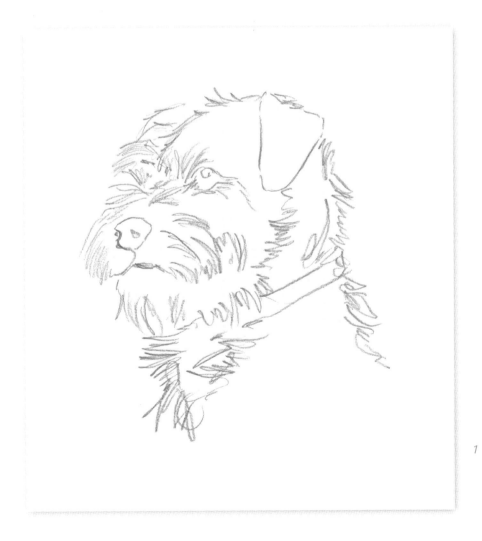

1 Draw the main contours using sweeping strokes of a 6B graphite pencil.

2 Colour in the Border Terrier's eye and ear using the 6B graphite pencil, making the bottom of each one a little darker. It is important to leave a blank glint of light in the upper part of the pupil. Colour in the nose and the dog's collar in the same way, leaving some lighter areas free on the nose. For large areas, hold the pencil at a slight angle to the paper, so that virtually no individual lines can be seen. Shade the background behind the face in a light shade of grey.

3 Carefully smudge the background with your fingers until there are no more lines to be seen here and the surface is a fairly uniform shade of grey. Using the HB graphite pencil, draw some small, fine hairs in the fur and then lightly smudge the area around the muzzle, behind the head and at the throat, as well as on the animal's forehead, using your fingers. Finally, draw more small fine hairs over the smudged areas using the HB graphite pencil to add some depth to the texture of the fur.

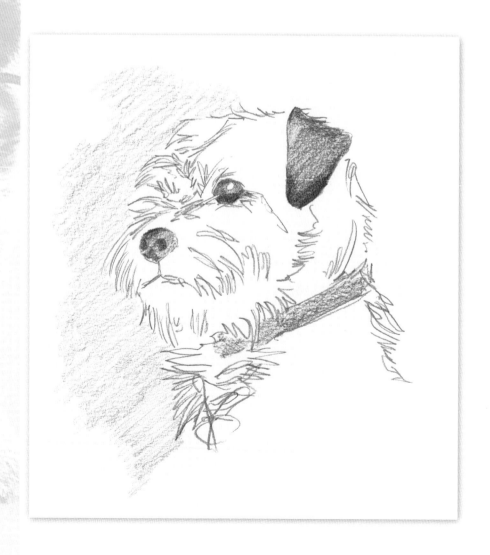

2 Add the tones of the ear, eye, nose and collar.

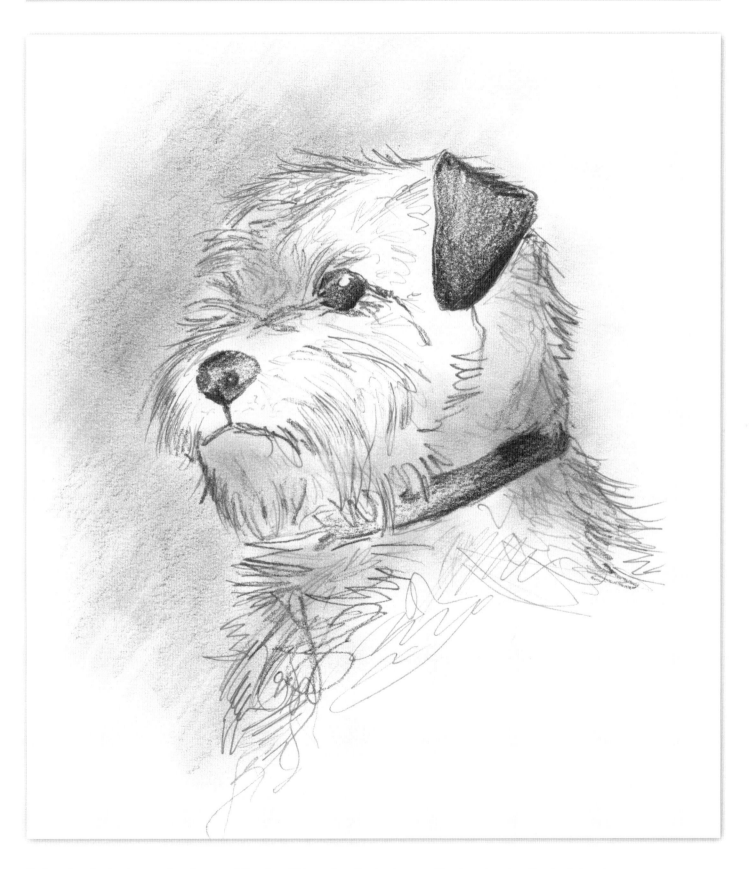

3 *Smudge the background and parts of the dog. This pushes the background back and makes the dog's head more three-dimensional.*

Irish Setter

The Irish Setter is a large, elegant dog. It is characterised by its rich, chestnut-brown coat, without any trace of black, which sometimes contains little scattered flecks of white. On the head, the fronts of the legs and the tips of the drooping ears the hair is short and fine. Over the rest of the body and along the legs, the hair is medium in length, lying flat and without any curls or waves. The ears are medium-sized and have a fine texture. They are deep and set far back.

Distinguishing characteristics

- The body is slim and athletic with long legs.
- The muzzle is long and the floppy ears are medium-sized.
- The reddish brown fur is silky and lies flat.

Technique tip

The typical colour of an Irish Setter is best portrayed using the warm tones of brown sepia and red chalk. Start with a mid-tone that can be rounded off with a lighter one and finally a darker shade. Carefully placed black accents will give the drawing a more intense brightness.

Step-by-step practice picture: Irish Setter

1 To prevent the paper you are working on from slipping while you are drawing, attach it to the table or a drawing board using masking tape. Now use light sepia to sketch the basic shape of the head and the pointed muzzle, as well as the long fur of the ears. (Notice that the muzzle is almost as long as the top of the head.) Use the same pencil to shade the darker areas, such as those on the muzzle, at the back of the head and at the throat. Next add the darkest tones with the charcoal and smudge them with your fingers. Ensure that you work sparingly with the charcoal to avoid getting a large darkened area when smudging. Draw some black strokes in the fur that you can smudge to fine, black lines using your finger. Lightly shade the nose and eye. Finally, rub the stump carefully over the charcoal to blend it.

Materials required
+ *Drawing paper*
+ *Masking tape*
+ *Light and dark sepia pencils*
+ *Chalk (soft) pastel in brown-red or cadmium red*
+ *Kneadable eraser*
+ *Charcoal*
+ *Masking tape*
+ *Stump (paper blender)*
+ *Fixative*

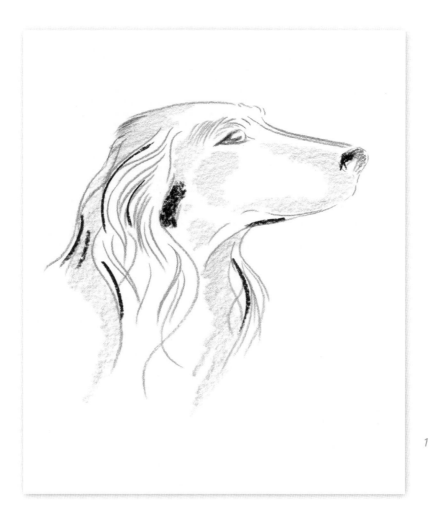

1 Sketch in the basic shapes in light sepia and then add a few judicious charcoal accents.

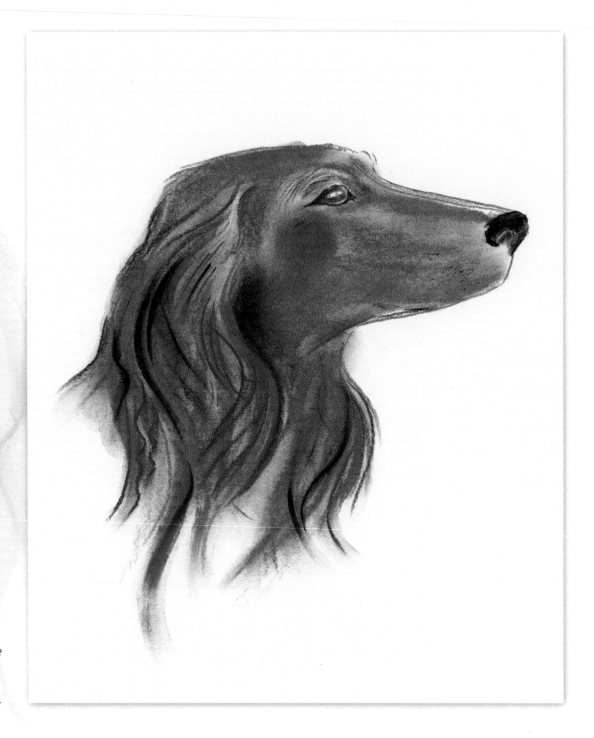

2 Use pastel to enrich the
 colour of the fur and
 then develop the eyes
 and nose with charcoal.

2 Now fill in a large part of the dog's head using the chalk pastel and smudge this carefully, always working in the direction of the flow of the coat. Leave some places blank as glints of light. Fix the drawing and leave it to dry thoroughly. Create the whiskers by smudging little dots of charcoal with your finger. Use the charcoal to work on the eye and nose again and then put the finishing touches to them with the stump, leaving a light reflection in the eye and around the edge of the nostril. Apply a coat of fixative to protect the drawing from smudging.

Mongrel

A crossbred dog can be any size, shape or form but if you examine its features you will find that you can draw parallels with known breeds to help you decide the best way to capture it. In the demonstration that follows, for example, the dog in question has the intelligent gaze of a Rough Collie, the square nose of a Border Terrier and the silky soft hair of an Irish Setter.

Step-by-step practice picture: mongrel

This picture is drawn using only hard lead and graphite pencils the better to reproduce the fine fur texture of the long hair. The head has a rounded shape and the eyes are positioned on its midline.

Materials required
+ *Drawing paper*
+ *HB pencil*
+ *HB graphite pencil*
+ *Kneadable eraser*
+ *Fixative*

1 First sketch out the basic shape using loose strokes of an HB pencil, drawing in the eyes, nose and mouth. The flow of the fur should be drawn with sweeping lines. Pay attention to the lighter areas in the fur. When you are happy with the outline of the drawing, start to work in more detail on the texture of the fur using the HB graphite pencil.

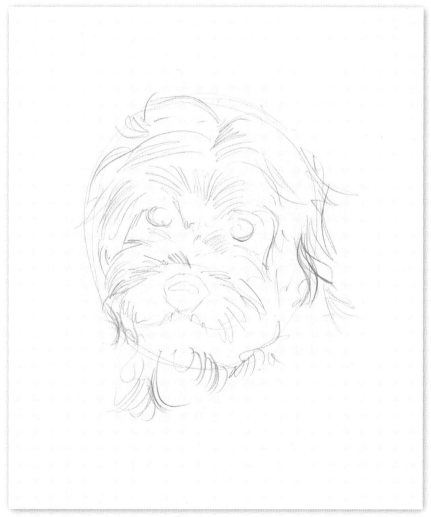

1 Lightly sketch in the basic shape of the dog's head and indicate the flow of the fur using an HB pencil.

2 When working on the fur with an HB graphite pencil, it is important to keep to the flow of lines, working in the direction in which the hair falls. To the left and right of the neck the hair is slightly darkened so that the head stands out a bit against the body. The fur is also drawn more strongly at the back of the head to suggest depth. Some hairs overlap the eyes at the inner edges. Make sure you draw the glints of light in the eyes correctly at this point. Start to shade the eyes and nose, taking care to leave the glints free.

3 Now make the outer corners of the eyes subtly darker and smudge some of the areas of graphite carefully with your finger to make the hair appear softer. Shade the background with the HB graphite pencil in a light grey and fade out the shading towards the edge. Erase some strips of the background using the kneadable eraser to create an interesting effect with the shading. Give the eyes and nose a three-dimensional effect using fine lines and light smudging. Finally, apply fixative to prevent the graphite pencil from smudging further.

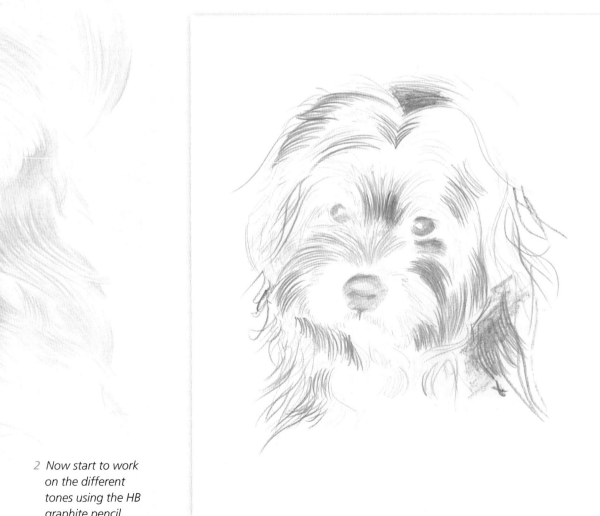

2 Now start to work on the different tones using the HB graphite pencil.

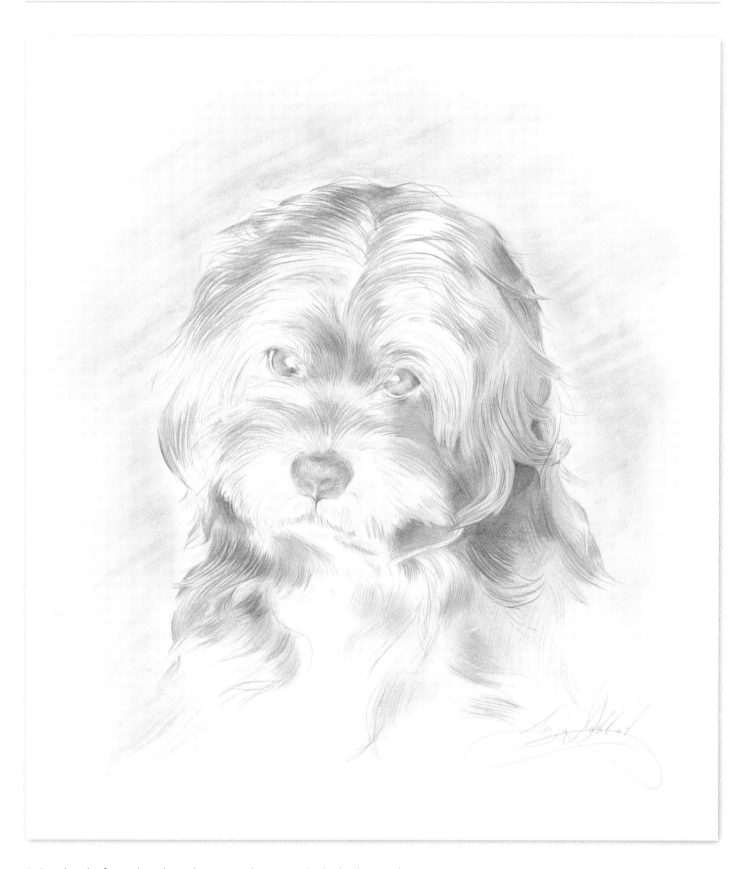

3 Develop the fur and work on the eyes and nose. Put in the background.

Lesson 2: cats

Learning goal
Learn how to draw cats of different proportions in a variety of positions and to indicate body language.

Cats are popular pets and equally popular as subjects for drawing, as they have a graceful and proud image. Their elegant appearance has inspired many artists for centuries. Learning how to capture the look of different breeds swiftly and effectively is of great help, so on the following pages you will find some short summaries of popular breeds, describing their most important visual features. Some suitable drawing techniques are suggested and you will also find a practice picture for each breed described.

Head shape

Cats' heads differ considerably in profile, depending on the breed. The illustration below shows the profiles of a Siamese cat, a European shorthaired cat and a Persian cat. The Siamese cat has the longest muzzle of the three and a relatively flat head, whereas the common European shorthaired cat has more regular proportions. Persian cats, on the other hand, have a flat and sometimes even a slightly inwardly curved face. They have a little snub nose and distinctive cheeks.

The characteristic shapes of cats' heads may be round as in Persian cats, triangular as in Siamese cats, or square as in the Maine Coon. The round shape depends upon the breed, the weight of the cat and/or the length of coat. A triangular shape is formed by large ears and a pointed muzzle. In the square shape, the cat's muzzle is relatively broad and somewhat pronounced. All three shapes can be found in common domestic cats. I have three European shorthaired cats, for example, and each one has a differently shaped head. The female cat has a round face, the older tomcat has a square face and the very young tom has a triangular face.

Proportions of young and adult cats

Young cats and older cats not only differ in terms of size, but also in terms of their whole body construction and face. By looking at the illustration, right, which shows a kitten, a half-grown cat and a fully grown cat, you can see this difference quite clearly.

The body of a kitten is very rounded and stocky overall, giving it a chubby appearance. The ears give the impression of being too small. It is the other way around with 'teenage' cats that are not yet fully grown: in contrast to kittens, they appear gangling, with limbs that have got too long and their ears seem to be much too big for their little heads. The teenage kitten's head has a triangular shape that looks angular. Fully grown cats, on the other hand, have the

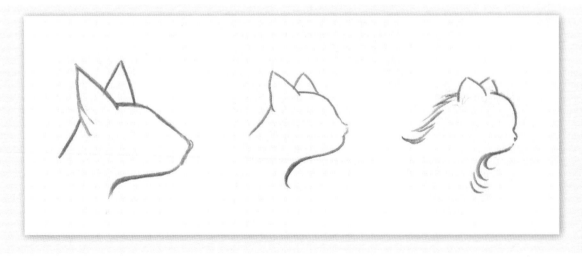

Siamese cats (left) have the longest muzzles and the flattest heads. Most cats have an even head shape (centre) while Persian cats have a very flat profile (right).

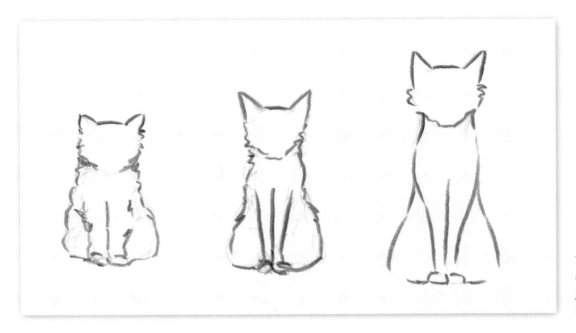

The proportions of a kitten compared to those of a young, 'teenage' cat and a fully grown cat.

balanced proportions we are familiar with. The head, body and limbs appear in proportion.

Tail

For most breeds of cat, the tail is the same. Exceptions are long-haired breeds, such as Persians and the Maine Coon. Yet even with these two examples, the shape of the tail is only different due to the composition of the fur.

The Persian cat's tail looks bushier than the Maine Coon's because of the lighter, fluffier fur, whereas the Maine Coon's very long tail fur hangs downwards. In the illustration, three cats' tails are compared: the Persian cat, the Maine Coon and the European shorthair. When drawing a cat's tail, it is important to portray the texture of the fur as realistically as possible with lines and hatching.

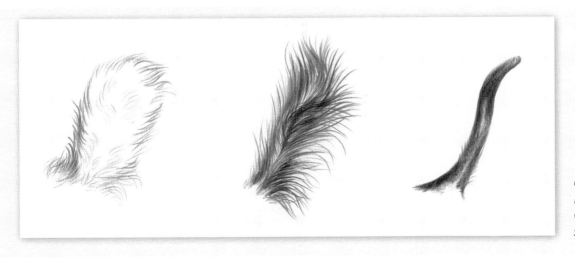

Characteristic cats' tails: Persian cat (left); Maine Coon (centre) and shorthaired cat (right).

Domestic shorthair cat

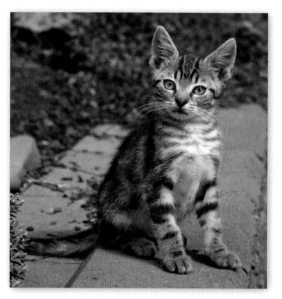

American shorthair, British shorthair and European shorthair cats are basically the same type of common domestic cat as far as drawing them is concerned. They come in a variety of colours with a range of markings from bright patches to red tabby. Their heads are rounded, yet some have an angular shape as can often be seen in older tomcats. The eyes are round or slightly almond-shaped and the body is clearly defined due to the short hair. They have clear lines and nice proportions. The shorthaired cat can be found in a vast number of homes throughout the world so it is a good subject for the first practise picture, but to add a little bit of a challenge it is going to be a kitten. Large ears and a tiny face are the striking features of kittens.

Technique tip

With care, short fur can be conveyed in any medium. If you are working with Indian inks, for example, the edge of the fur can be precisely portrayed with uneven lines. Using pastels, you can draw a nice fur texture with lots of short strokes in different shades of colour and even using an ordinary pencil you can achieve appealing soft grey shades.

Step-by-step practice picture: kitten

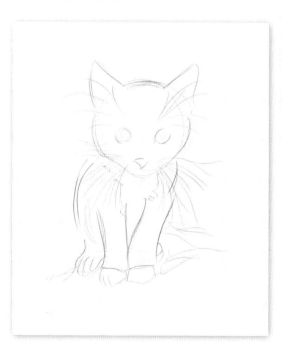

1 Roughly mark in the outlines of the kitten.

Materials required
+ *Drawing paper*
+ *HB graphite pencil*
+ *HB and 6B pencils*
+ *Kneadable eraser*
+ *Fixative*

This kitten is shown from a slightly bird's-eye view, which makes the head appear almost as large as the body. The eyes are round and the whiskers are very pronounced.

1 Observe the lines of the first stage of the drawing in detail before you start to draw: some lines are broken, others are unbroken. Individual lines are drawn in dashes to give the texture of the fur. Start by drawing the

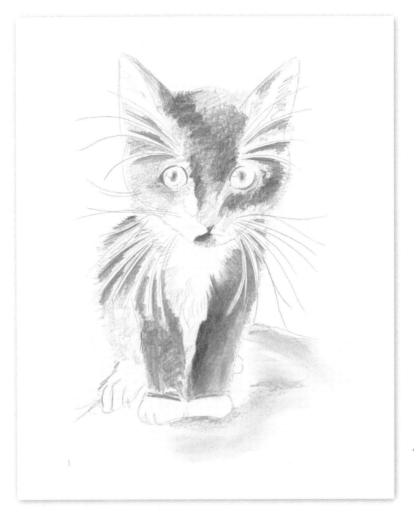

2 Shade the dark areas – but not too much – avoiding the fine lines of the whiskers.

outline and the most important shapes, as well as the kitten's whiskers with the HB graphite pencil. When sketching, avoid making the lines too thick, so that you can retouch them if you need to. You can indicate the ground with a few thin lines. Check you are happy with the position of everything before proceeding.

2 Once you have drawn the basic lines, shade all the dark areas with the HB pencil. Do not make them too dark, so that you can gradually incorporate further shades of grey into the drawing. Place a sheet of paper beneath your hand while you are drawing to avoid smudging accidentally. For the time being, leave a narrow strip blank just before the edge of the body,

which will be filled in later with the texture of the fur. Leave the whiskers as thin white lines when colouring in the fur. Shade the eyes in light grey – notice that the oval pupils do not have sharp outlines. Sharpen the pencil often during this step so that you can do finer work. The lines on the right and in front of the kitten can now be smudged using your finger to give a three-dimensional look.

3 Using the 6B pencil, work more on the fur: draw lots of little strokes around the outer contours of the kitten, always moving your pencil outwards towards the edge. Try to make the whiskers even finer by carefully placing short, fine lines next to them, thereby increasing the black area.

Now draw a glint of light at the edge of the pupils in the round eyes. Make the area around this glint subtly darker with the pencil. The shape of the light glints should be copied as exactly as possible, as these are very important for forming the overall expression of the cat's face.

If the glint is in the wrong place, it can give the impression that the cat is cross-eyed. Slightly darken the edges of the kitten's ears, but leave a little white space in the middle. Draw some small, fine hairs here too. Apply fixative to the finished drawing to prevent the graphite pencil from smudging further.

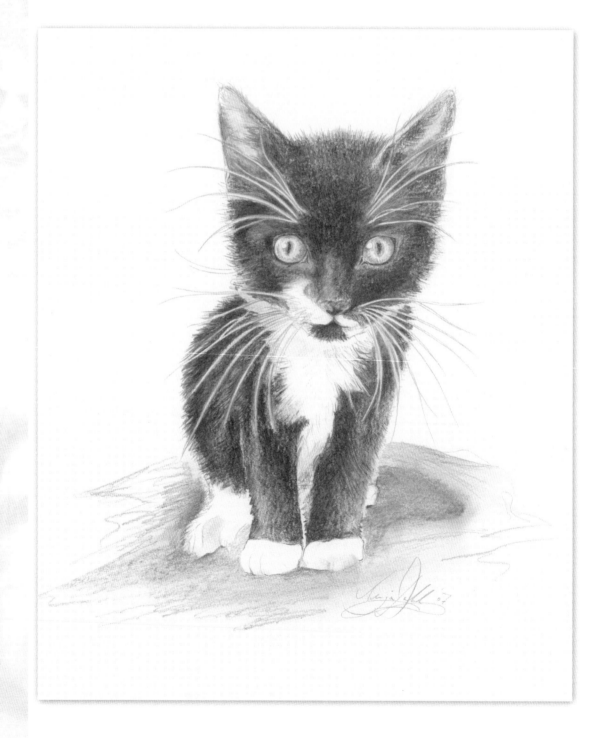

3 Darken the deep shadows and develop other areas using the 6B pencil.

Maine Coon

The Maine Coon is a really attractive large cat, with a medium-long coat, an impressive and usually white mane and an imposing tail. Its eyes and ears are strikingly large. The fur is somewhat shorter on its head and shoulders and longer on the tummy and flanks. Overall, its body shape is long and rectangular. The Maine Coon cat appears even larger than it actually is due to the fur that makes up approximate 40% of its body volume. The transition from the body to the neck is barely distinguishable. The head is medium-sized and fairly square or wedge-shaped. Its large, round eyes are widely spaced and can be different colours. Its nose is broad and its cheekbones are very pronounced. In terms of colour, the Maine Coon is very variable: it may be black, white, brown, red or grey, with either one, two or three colours. The markings range from flecked to striped.

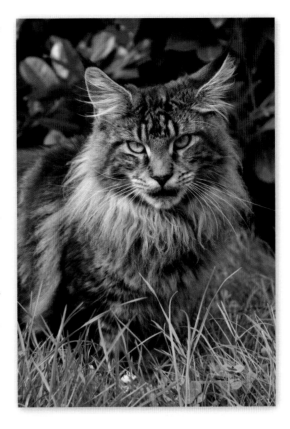

Technique tip

To start with at least, long fur is best drawn with a pencil because the individual hairs can be picked out with fine hatching. If you work with pastel, charcoal or red chalk, it is important to add in a few fine lines after smudging.

Step-by-step practice picture: Maine Coon

Materials required

✦ *Drawing paper*
✦ *HB pencil*
✦ *Kneadable eraser*
✦ *Fixative*

1 First draw just the basic features of the face, taking care to get the correct perspective for the eyes: the slightly angled position of the head means that the right eye is only half as wide as the left. When sketching, use a pencil that is very slightly blunt, so that you get softer lines that are easier to erase, just in case one of the lines is not in the right place first time. The Maine Coon's nose is sweeping and relatively long compared with those in other breeds of cats. Yet to give the nose a delicate appearance, the lower area must be narrow. Start to indicate shading in the eyes and just hint at the pupils. Mark the roots of the whiskers with fine, irregular dots and indicate the hairs using fine, sweeping lines.

2 Mark in the stripes using a light hatching. The stripes run vertically above the nose but horizontally over the eyes. Make the fur a bit darker at the base of the ears and draw in some small, fine hairs.

From the back of the head onwards, draw in the long, soft fur using sweeping lines. The lines get longer the lower they are. To make the head stand out from the body, hatch around the cat's throat to create a darker tone that pushes the area back. Make sure that the hatching runs in a slight curve to the right to emphasise the body contours and create a three-dimensional effect.

The white collar of the Maine Coon cat can be made to stand out by darkening the lower part of the fur in some places. Finally, draw in the white paws and, if necessary, erase any unwanted hair in the long fur at this point. Draw a folded blanket in front of the cat and smudge this when finished. Apply fixative to the finished drawing to prevent further smudging.

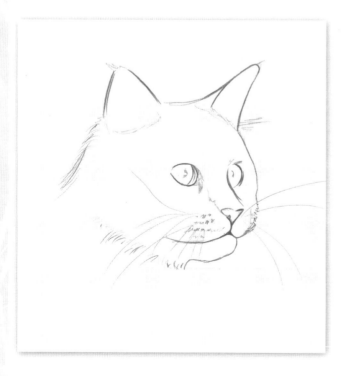

1 Lightly sketch the basic head shape and facial features.

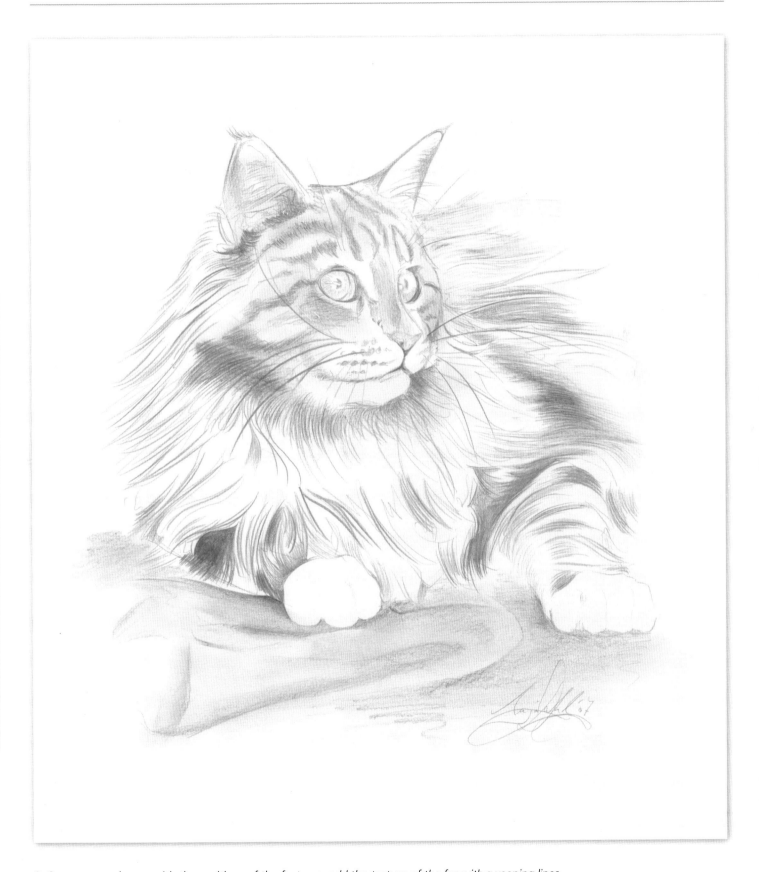

2 Once you are happy with the positions of the features, add the texture of the fur with sweeping lines.

Persian cat

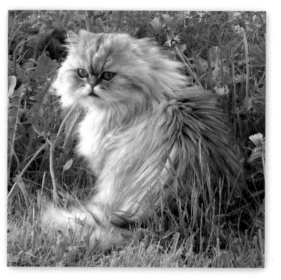

With Persian cats, most of the body contours are hidden by the long, fluffy fur. They move proudly and gracefully, kings of all they survey! Their high cheekbones and little snub noses give them very compact faces. Their ears are rounded, and are largely lost in the long fur. Their delicate legs appear wider than they actually are, due to all the hair. When drawing, it is important to pay attention to the direction in which the fur lies if you want to produce a convincing picture. By using sweeping lines that are sometimes broken, you will achieve some nice drawings. Delicate lines, using a sharpened pencil, work really well here to portray the long, fluffy hair.

Technique tip

The fur of a Persian cat, like that of a Maine Coon, is often best drawn with a pencil. The fine hatching will make the fur appear soft and elegant.

Step-by-step practice picture: Persian cat

1 Start by sketching in the basic shapes and the texture of the fur using lots of broken lines.

Materials required
+ *Drawing paper*
+ *HB pencil*
+ *Kneadable eraser*

1 When sketching, start by determining the outline of the head and the positions of the facial features. The very small ears of a Persian cat give the head a square shape, and its face looks very different from the faces of other breeds of cat due to the extremely short nose. The distance between the eyes is larger than the distance between the eyes and nose. Take care when drawing to ensure that the forehead is wider and the cheeks more pronounced than is the case for most other cats. In this sketch, a large part of the face has been left white and the fur is only subtly drawn in. Look closely at the fall of the fur as you sketch.

2 Now draw in the eyes, giving them a slightly oval shape, and go around them again, with the inner corner of the eye coming to a point and the outer corner being rounded. Draw in a glint of light in each of the small pupils. Now shade the eye in light grey. To portray the soft texture of the fur, use lots of separate areas of hatching running in different directions. The spaces in between are left white. Finally, add some individual, sweeping hairs using delicate lines. By subtly darkening individual parts of the fur on the ears, neck and legs, the pale drawing will stand out against the white background.

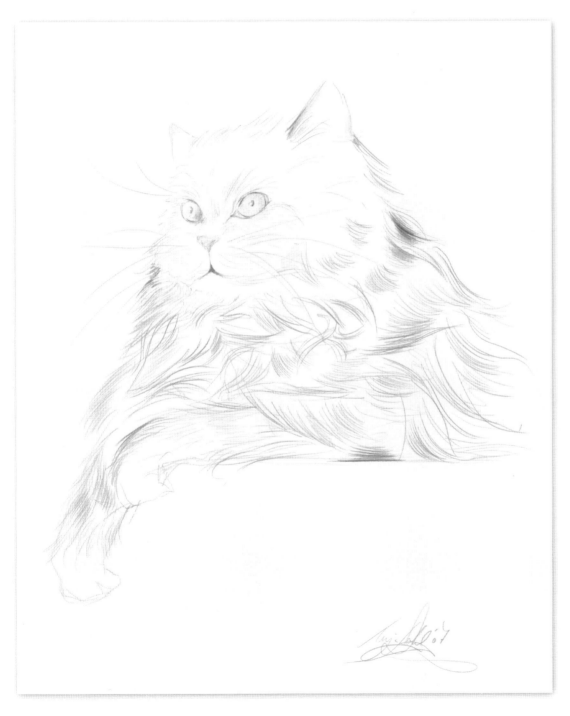

2 Work on the fur and facial features. The soft, flowing texture of the fur is largely absent on the head.

Chartreux

Chartreux cats originated in France. With their bluish-grey fur and golden eyes, they exude an almost mystical charm. The large, round eyes give them a soft, friendly expression that reflects their character too. The Chartreux cat has a robust, solid body construction with wide shoulders and a strong, thick neck. Its head is round with full cheeks and its nose is straight and broad. The ears of a Chartreux cat are small to medium in size and sit high on the head; at their base, they are straight and narrow, and they are rounded at the tips. The fur of this type of cat is dense and thick with a silky sheen and can contain all shades of grey, from light grey through to bluish-grey.

Technique tip

The soft, silky fur of the Chartreux can be beautifully portrayed using chalk (soft) pastels and pastel pencils. This is the best way of showing the beautiful colour of the fur. First, draw some light hatching in grey that can then be smudged using a stump. Using white chalk, subtly hint at the velvet sheen of the coat.

Step-by-step practice picture: Chartreux

1 Plot the shape of the head and positions of the facial features using light strokes and an HB graphite pencil. A Chartreux cat has very rounded facial features and rounded tips to the ears. Due to its broad neck, its head does not stand away from the body very much. When sketching the basic lines, make sure that the cat does not look too fat. The eyes of a Chartreux cat are round, with much reduced eyelids, giving them an owlish look.

Materials required
+ *Drawing paper*
+ *HB graphite pencil*
+ *Pastel pencils in grey, white, dark yellow and orange*
+ *Chalk (soft) pastels in olive green and grey*
+ *Light sepia pencil*
+ *Charcoal pencil*
+ *Stump*
+ *Kneadable eraser*
+ *Fixative*

2 Using the grey pastel pencil, hatch along the edges of the basic lines, leaving some parts white. You will fill these later with light sepia and then smudge with a stump (paper blender). Place a sheet of paper beneath your hand, so that you do not accidentally smudge your drawing as you work on it further. Lightly outline the eyes of the cat with a charcoal pencil and carefully smudge the line with the stump. Finally, colour the irises, first in yellow and then using the orange pastel pencil.

3 Now draw in the pupils using charcoal and leaving white glints where you see them. With Chartreux cats, the texture of the fur is barely visible due to the thick, velvet coat. Work over the fur with the light sepia pencil and then lightly work over this with the white pastel pencil to hint at the velvety sheen. Apply the white sparingly, otherwise it will not look realistic. Smudge the colours of the fur. Now, using the olive green chalk pastel, roughly texture the background around the subject by

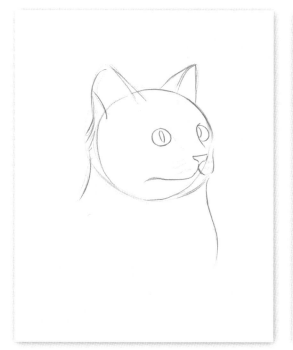

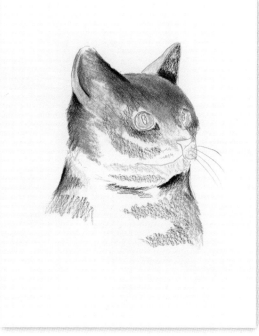

1 Plot the shape of the head and the positions of the facial features lightly using an HB graphite pencil.

2 Broadly colour the fur using the grey pastel pencil and start work on the eyes.

43

stroking the flat chalk over the paper to create broad hatching. Repeat this process with the grey chalk pastel. In this drawing the lower left of the cat has also been roughly textured in this way. Smudge the background loosely using your fingers, leaving the area immediately around the cat white. Finally, fix the picture.

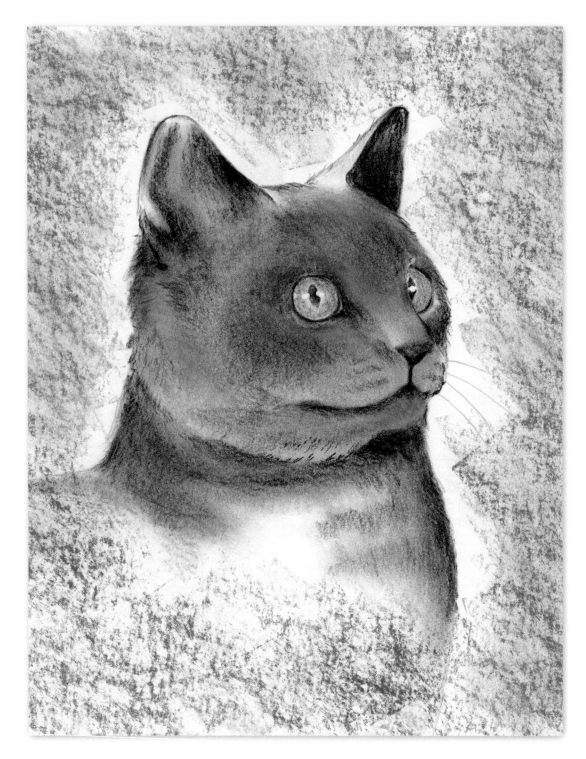

3 Develop the fur, lightly hatching with the white pastel pencil, and work on the facial features and background.

Siamese cat

The unusual and extravagant appearance of the Siamese cat is largely due its slim, athletic-looking body. The dark extremities are actually white when the cat is born; they take on their colour in the first few months. This colouring can appear stronger in outdoor cats than in pets that live entirely indoors as the colouring develops on the coldest areas of the body. The fur is also dark on the face. The striking, triangular head shape is emphasised by the large ears. The eyes of a Siamese cat are almond-shaped, medium-sized and a striking blue.

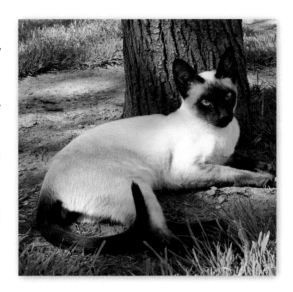

Technique tip

Sepia pencils are good at describing the short, silky fur of a Siamese cat. The shiny blue eyes can be reproduced really well with a blue pastel pencil.

Step-by-step practice picture: Siamese cat

Materials required
+ *Pastel paper*
+ *HB graphite pencil*
+ *Charcoal*
+ *Light and dark sepia pencils*
+ *Pastel pencils in white, dark yellow and blue*
+ *Stump*
+ *Kneadable eraser*
+ *Fixative*

1 Lightly sketch the basic lines of the Siamese cat using the HB graphite pencil. The triangular head is positioned low on the neck, due to the cat's crouched position. The body is egg-shaped and the back limbs are covered by the tail. Only the front paws are sticking out a little. The ears are positioned slightly to the front and are very wide at the base. Initially, just indicate the eye lightly. The line from the forehead to the top of the nose runs in a straight line down over the bridge of the nose. Sketch the nose as a small triangle.

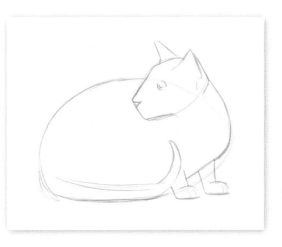

1 Plot the basic shape of the body, which is egg-shaped.

Tip
Use a craft knife to keep the sepia pencils sharp – they tend to break easily when sharpened with a pencil sharpener.

2 Now draw over the body contours using the dark sepia pencil, making sure that the pencil is sharp so that the lines are not too thick and inaccurate. Carefully shade the fine patterning on the face of the Siamese cat using the light sepia pencil. Only press lightly on the tip of the pencil so that you get clean lines. These areas should be smudged afterwards using a stump (paper blender). Now shade some more using the dark sepia pencil in the middle of the areas that have already been filled in. Smudge this too using the stump and then shade a smaller area using charcoal. This gives a soft, graded colouring to the drawing of the fur. Darken the eyes above the lids and at the outer corners and colour the irises using the blue pastel pencil. Notice that the fur is lighter at the inner corner of the eye and the pupil has a little glint of light in it at the top. The body of the Siamese cat is white and should only be lightly shaded with light sepia in the lower mid-section and then smudged with the stump. Colour the paws using light and dark sepia, dark yellow and charcoal. The tail should be almost completely darkened using charcoal but the base of the tail and front paws can be slightly lightened using the dark yellow pastel pencil.

Now work over the drawing again with all the shades used. Finally, draw in the fine texture of the fur on the head and tail using the white pastel pencil. Apply fixative and leave to dry before using the HB graphite pencil to 'ground' the cat by suggesting a shadow using light, horizontal hatching.

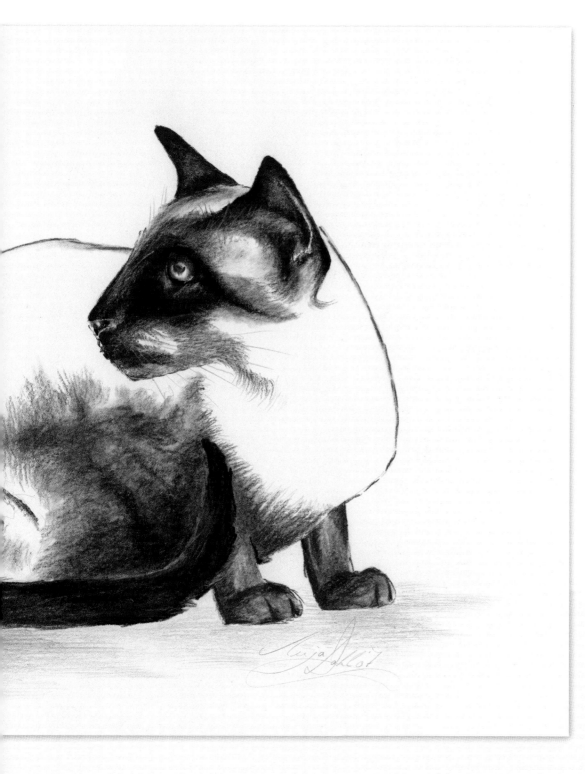

2 *Overlay hatching in
different colours on
the face, belly, tail and
front paws.*

Lesson 3: birds

Learning goal
Learn how to draw birds and their feathers using different materials and techniques.

Pet birds are particularly good drawing subjects because there is plenty of time to study and observe them from close up. The basic shapes are easy and the outline is quite quick to draw. The plumage will have a more delicate effect if only parts of the outline are indicated. The skill lies in stopping at the right moment. You do not need to portray every line down to the last detail and you should not do so. Often, an indication of a line has a stronger effect than a photorealist approach to the subject. In the garden, species of birds like the magpie, robin or the common sparrow make excellent drawing subjects too. After you have looked at a bird for long enough and studied its form, you barely need the actual subject to compose a nice drawing.

The basic shape of a bird's body is like that of an egg, which makes drawing the outline relatively easy. The extremities, such as the legs and wings, can be quickly added and it is more or less the same for the beak. Always start with the body and work on the shapes one by one.

Sparrow

Sparrows can be found in any garden. They are fun to observe and draw, as they are very common and happy to hang around if you scatter some food. They barely differ in terms of size and colouring. Their feathers may be in ordinary shades of brown and grey, with white down. Their little heads have simple, dainty beaks and button eyes.

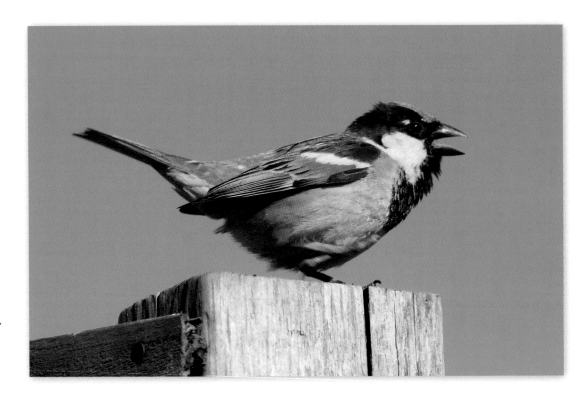

The feathers of a sparrow are made up of various shades of white, brown and grey.

Step-by-step practice picture: sparrow

Sketch the egg shape of the bird using an ink pen. Leave out the area of the head and the base of the tail to avoid an unwanted line there later. The head is a slight oval. Draw the outlines of the tail feathers using several long lines and then colour the tail with diagonal hatching. Briefly indicate the legs with thin lines. Now randomly place lots of irregular hatching on the head, breast and back, darkening the areas along the back and behind the head. Make the ground beneath the bird a bit darker to suggest a shadow. Colour the eye almost solid black but leave a little white showing through for the glint and at the bottom. Finally, colour in the beak using diagonal hatching.

Materials required
✦ *Drawing paper, suitable for ink pen*
✦ *(Rapidograph) with a 0.18mm nib*

This pen-and-ink drawing was made using random hatching in different directions.

Budgerigar

A budgerigar is approximately 18cm (7in) long. It has a black wave pattern on its neck, shoulders and wings. The distance between the wave lines is smaller on the head, getting wider further down. The down on the belly has no pattern. The budgerigar's eyes are round and encircled by a ring. The beak is small, thick and bent clearly downwards. The budgerigar has spots at the throat.

Step-by-step practice picture: budgerigar

Materials required
+ *Drawing paper*
+ *HB pencil*
+ *Kneadable eraser*
+ *Thin stump*

1 First draw a small oval for the head and a larger, longer oval for the body. Then add the tail feathers to the lower area of the body. Indicate individual feathers on the wings with regularly placed curves. The eye is positioned in the middle of the top half of the small oval that forms the head. Now draw the beak to the right of it and establish the direction of the wave pattern on the head. Merely indicate the budgerigar's foot and the bar it is gripping.

2 The wave pattern on the bird's head should be drawn in a semicircle that runs parallel to the eye. It fills half of the face. This pattern is portrayed with broken stripes. Draw each stripe using the pencil, zigzagging the point over the paper so that the contours of the stripe appear irregular. Now work on the wings. The curves of the wings should be left white at the outer edge while the inner areas should be shaded a light grey. Finally, darken the left side of the budgerigar and the throat, including the area of down, using hatching. Shade the beak in the same way. Now carefully smudge these areas with your finger. If this makes the pattern too faint, go over it again. Smudge smaller areas on the beak and in the plumage individually using the stump (paper blender).

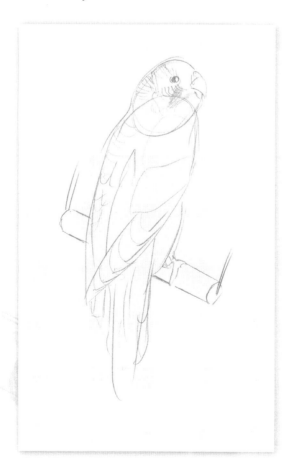

1 Indicate the head and body of the budgerigar with two ovals. Add the basic features.

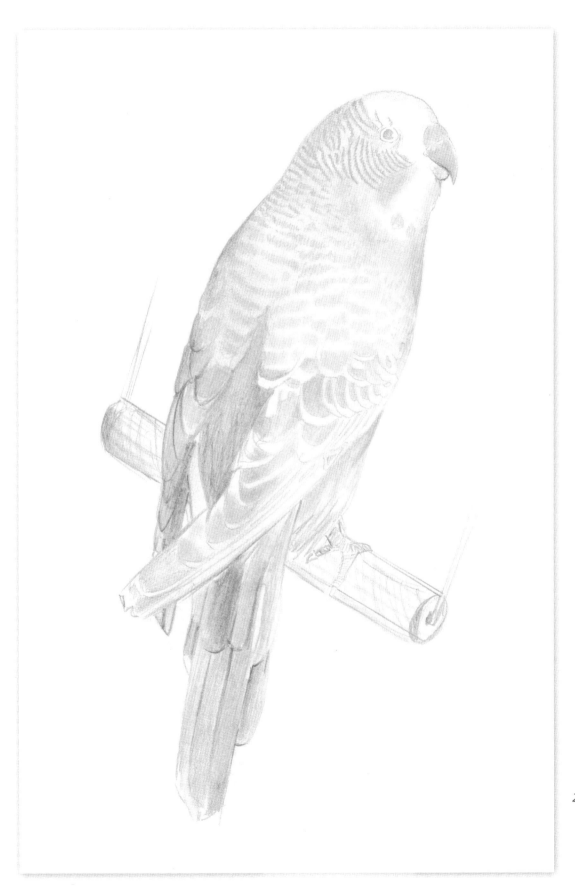

*2 Add the patterning
and different tones
then carefully smudge
the fine grey shading
using your finger or
the paper stump.*

Magpie

Even if the magpie has a dubious image and is described as a thief, it is a beautiful and interesting bird and in most places there are plenty of opportunities to spend time observing and drawing one. Its striking black-and-white colouring is unmistakable and its size makes it really magnificent. The magpie differs from all other ravens in that it has a long, graduated tail, with tail feathers of clearly different lengths. The tail is often as long as the body. The belly, flanks and shoulders of the magpie are white. The primary feathers are also largely white. The rest of the plumage is black with the wing and tail feathers shimmering with other colours. In the European species, the wing feathers are a bluish colour and the tail feathers are greenish.

Step-by-step practice picture: magpie

Materials required
✦ *Drawing paper*
✦ *HB pencil*
✦ *Charcoal pencil*
✦ *White chalk (soft) pastel*
✦ *Thin stump*
✦ *Kneadable eraser*
✦ *Fixative*

First sketch the outlines of the bird as an oval. Do not press too hard with the pencil on the paper and just draw fairly light, discreet lines, as otherwise light areas will be visible when you add colour later with the charcoal. Now gradually add the basic features of the bird. Mark the darker areas with light hatching. Make sure that the wings are only half as long as the tail. The head of the magpie is slightly flattened and the beak forms a curve that merges straight into the throat. It is important that the eye is correctly positioned, otherwise the whole drawing will appear incorrect. Erase individual lines and redraw them until you are happy with the overall picture. Then roughly outline the branch on which the bird is sitting. Now colour in the black areas of the magpie using the charcoal pencil. Try to achieve soft transitions when doing this as charcoal will only smudge to a limited extent later and you want to achieve uniform black areas.

Leave some white strips on the bird's tail that you can go over again with white pastel after smudging. Leave a little point of reflected light in the eye and a narrow ring around the eye. These areas will also be emphasised with the white pastel later. Now smudge the black areas evenly using the stump (paper blender) and then use it to colour in the branch, as there will be enough charcoal particles on it to give the branch a subtle grey tone. Carefully wipe over the white areas in the bird's plumage with the stump. This will produce very pale shading. Unevenly colour in the legs of the magpie using charcoal and smudge the applied colour with the stump. Finally, draw some subtle white shading at the throat using the white chalk and carefully smudge it. Add white to the eye and smudge this too. When you are happy with the drawing, spray it with fixative.

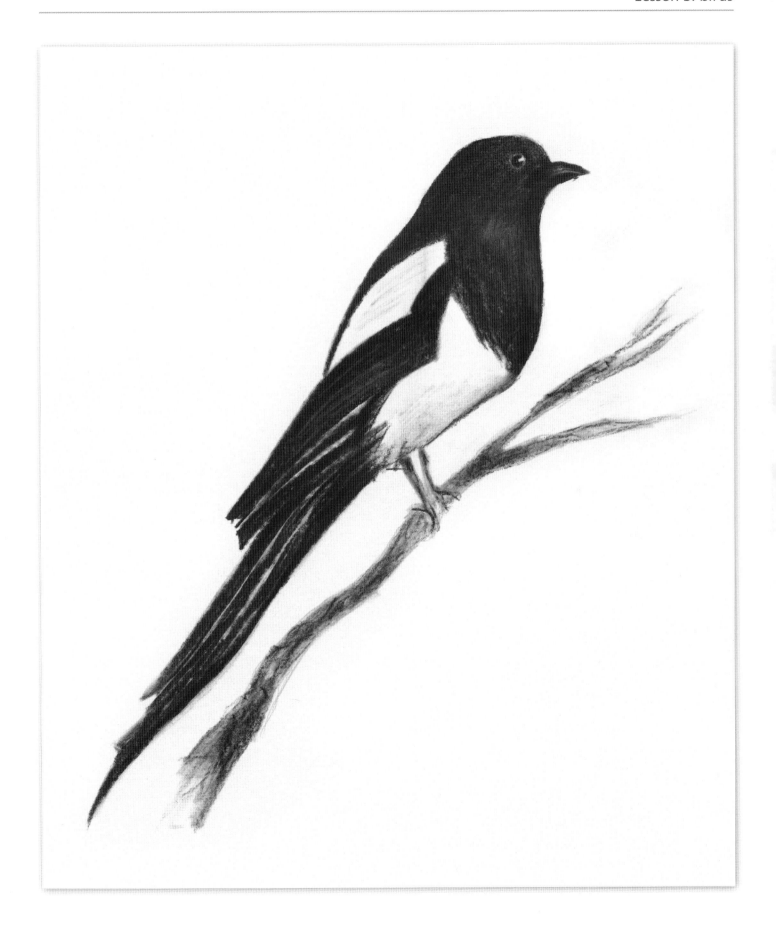

Lesson 4: horses

Learning goal
Learn the principles
for creating expressive
portraits of horses.

The horse is one of the largest and most imposing of our animal companions. Its impressive and complex physical form needs to be carefully studied and considered before embarking on a full drawing. It is very helpful to take a good look at its various body parts individually first and to study these thoroughly to make it easier to draw them later. The differences in the various breeds are not as distinct as with other types of pets, with the colour, size and shape of the head being the most notable.

The way that the mane falls or is arranged gives the animal an individual look. For example, if the mane is tightly plaited or knotted, this makes the neck stand out clearly and therefore appear broader. The style and arrangement of the mane will also affect the appearance of the ears and the forehead. The short coat means that the horse's muscles and sinews are clearly visible, and these should be indicated in the drawing with light shading if a realistic result is to be achieved.

Differences between the
various breeds of horses,
apart from sheer size, are
mainly to be seen in the
following areas:
① *Length of head.*
② *Size of ears.*
③ *Width of neck.*
④ *Width of head.*
⑤ *Shape and size of*
nostrils and mouth.

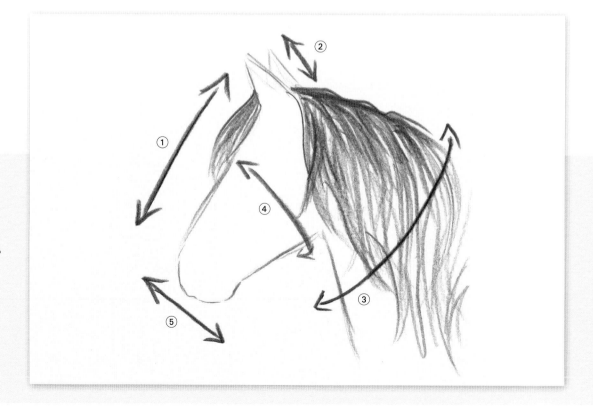

A horse's ears are basically tulip-shaped but the exact proportions depend on the breed.

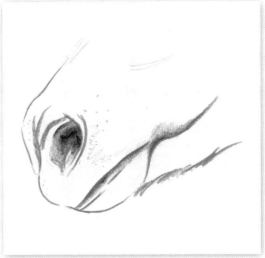

The mouth and nostrils are soft and malleable and usually grey or black in colour.

Eyes, ears and nostrils

A horse's eyes, positioned on the side of the head, are framed by fine lashes. The upper and lower eyelids give the eye an almond shape but the eye itself is actually large and round and stands out clearly. The eyes can be very expressive.

A horse's ears are also very important in terms of expression. They show the horse's mood: if the ears are laid back flat, this means that the horse is feeling threatened and is ready to attack; if they are pointing forwards, the horse is particularly alert. A horse's ears are roughly tulip-shaped, and similar to those of a German Shepherd dog.

The velvety nostrils of a horse are very sensitive and soft. They become dilated when the horse is agitated but when the horse is snaffling something edible, the nostrils fall into folds, while the mouth shapes into a point and the long tongue is visible. Note that the mouth and nostrils are a different colour to the rest of the face, often being grey or black.

Important characteristics of different breeds

The main differences between the breeds of horses are easy to explain: apart from the colour and the size of the body or differences in body construction, you should focus your attention in particular on the animal's head. Lineage is most usually apparent in the length and width of the head, the width of the neck and the shape of the mouth. So pay particular attention to these areas, when you draw a horse.

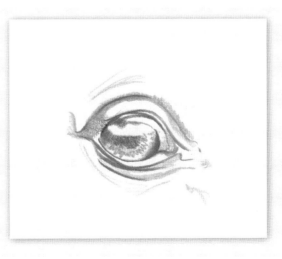

The large eyes of a horse are very expressive.

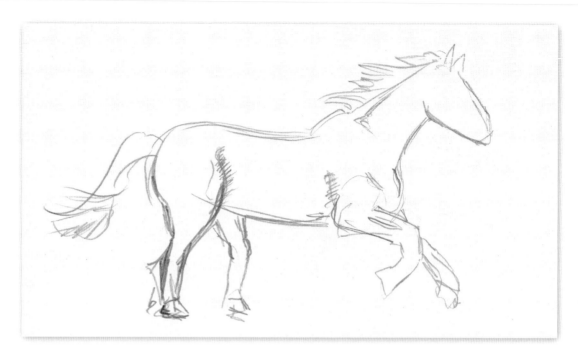

Practice sketching horses using an HB pencil and working with fine, flowing lines.

Practice sketches

As drawing horses is not all that easy, you should start out by making a practice sketch – or preferably several – before you start a drawing. This practice sketch should help you identify problem areas. The main purpose of a practice sketch is to become more familiar with and distinguish between certain shapes. This is not about aesthetics but more about function. To make a practice sketch, all you need is a sketch pad and an HB pencil. A graphite pencil is especially good for this too, as it can be used to cover larger areas.

Most of the problems with drawing horses relate to the legs. This is undoubtedly due to the range of movement in a horse's leg. The vastly changing angle of the leg in movement is difficult to capture, especially as the forelegs and hind legs are very different and can be moving quite fast. All the different muscles that are visible make this even more difficult. Care must be taken with all of the above in order to achieve a satisfactory and realistic result. First draw the parts that pose you the most difficulty. Even if the initial results are not

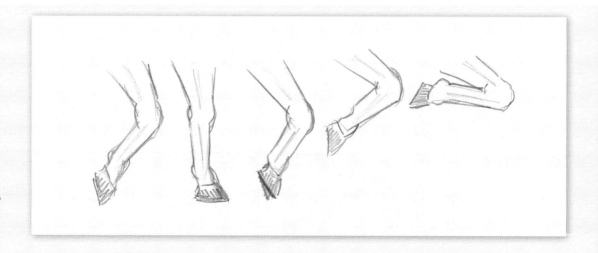

A horse's legs are flexible and can bend right back if needed.

particularly pleasing, they are important steps in recognising what you have done wrong. Which areas have been drawn too big, too small, too long or too short? The purpose of a practice sketch is not to get the perfect result first time, but to get closer to the desired form.

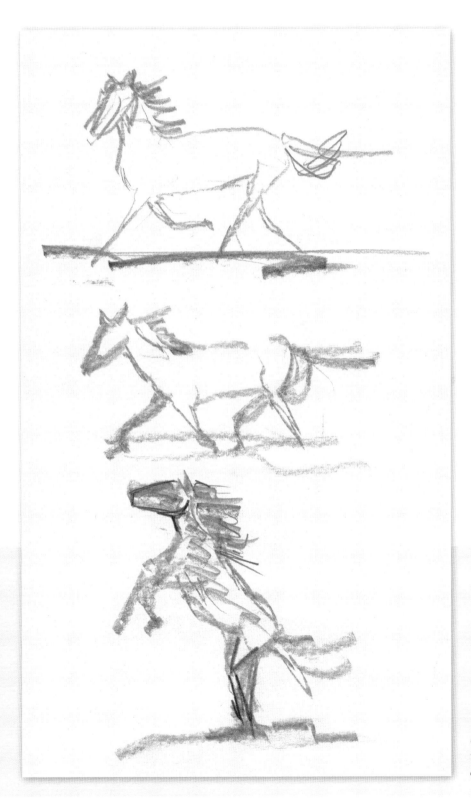

Use graphite or HB pencil to try sketching a horse in different positions.

Friesian

This distinctive large black horse with its solid body is a very imposing animal. In the past, the breed was used to pull funeral carriages but now it is popular for dressage, riding and driving. Its head is long with a straight profile, and it has lively eyes and neat, pointed ears.

The horse has a beautiful, long arched neck and its body is compact with a broad chest and a short, straight back. The tail is long and thick, and the coat is sleek and silky.

Step-by-step practice picture: Friesian

Materials required
+ *A3 drawing paper*
+ *HB pencil*
+ *Charcoal stick*
+ *Black chalk (soft) pastel*
+ *Charcoal pencil*
+ *White pastel pencil*
+ *Stump*
+ *Fixative*
+ *Kneadable eraser*

1 Sketch the outlines of the horse's head with the HB pencil, merely indicating the flow of the mane by way of a guideline – do not work in any more detail on this, as the

black chalk pastel covers so darkly that you will not be able to see the pencil lines anyway. Now take the piece of charcoal in your hand and brush it flat and with light pressure over the paper. Using your fingers, smudge the charcoal particles to give a uniform light grey shade and spray the picture with fixative. Leave the drawing to dry thoroughly before working on it further. Next, draw the mane using the black pastel and carefully smudge the strokes using your fingers. Draw a fairly light hatching around the eye and smudge it using the stump. Use the same technique to darken areas on the front of the muzzle and elsewhere on the face as required. Outline the nostrils in black and draw the mouth as a broad black stroke. Fix the picture again.

2 To make the head stand away from the neck more clearly, shade the centre of the neck and along the cheeks using the black pastel. Now emphasise the animal's cheeks a little with the white pastel pencil. Shade the nostrils so that the centre becomes lighter and leave a small area white. Work on the eye, leaving a glint of light placed slightly towards the back. The corners of the eyes can be subtly drawn in using the grey of the pencil. Now, using the charcoal pencil and the white pastel pencil, add fine hairs into the mane, including some individual hairs visible at the forehead and at the back of

1 Sketch in the proportions. By smudging the charcoal, the horse's head takes on a uniform shade of grey.

the head. Finally, shade the insides of the ears darker.

To achieve a more realistic portrayal of the horse's head, the veins beneath the eye can be worked on carefully using the charcoal stick. To do this, simply darken the coat a bit more to the left and right of the veins with neat shading. A light strip is left in the middle that widens out below. A dark triangle can be drawn into the wider end of the vein, making it look as if part of the vein is branching off. When you are finished, fix the drawing again.

Tip
Before fixing, make sure that you remove any spots at the edge of the picture using a kneadable eraser, as you cannot to do this once you have fixed the picture.

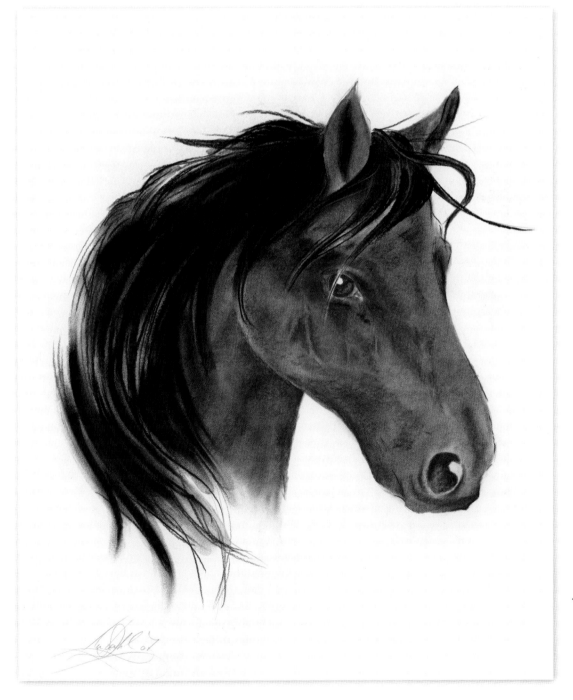

2 Continue to develop the head, using the white pastel pencil and the black charcoal pencil to draw some fine hair texturing into the mane.

English full-blood horse

The English full-blood horse is a very impressive horse. Its elegant head stretches out long with a straight forehead and large eyes. The animal's mane and tail are of fine, silky hair. When drawing, attention must be paid to the contours of the face. Between the nostrils and the eyes, and on the cheek and forehead of the horse, relatively strong elevations and indentations stand out on the surface that contribute to the overall impression of elegance. These can be nicely incorporated into the picture using light shading. The English full-blood horse has long, sloping shoulders, the neck is long and curved and the back is of medium length.

Step-by-step practice picture: English full-blood horse

Materials required
+ *A3 drawing paper*
+ *Red chalk pastel*
+ *Kneadable eraser*
+ *Fixative*

1 This practice picture is not sketched with a pencil first, but drawn directly with the red pastel, as the pencil lines would show through and dirty the colour of the pastel. First sketch just the basic lines.

1 Lightly sketch the horse using the red pastel, as pencil lines would turn the picture grey.

Do not press too hard with the pastel when doing this, to prevent the lines looking too intense. In this case, the horse's mouth is narrow and graceful with small nostrils and narrow ears. The fringe hangs over the horse's left eye. Notice that the right eye is sketched in a round shape and with a distinctive stroke on the upper lid. Draw in the pupil, leaving the white of the eye and the light reflection blank. This reflection is not a round glint as in most of the pictures in this book but it runs like a little streak of lightning into the top inner corner of the eye. Draw the nostril.

2 Shade the edges of the head so that the outline is no longer recognisable as a stroke but rather as an area that becomes lighter towards the middle. Now hatch over the horse's face to give it a three-dimensional effect. Add some hatching running diagonally on the cheek and between the nostrils. Shade the forehead, starting from the fringe. Notice that some hatching has also been placed parallel to the sides. Three further narrow areas of hatching can be placed centrally above the mouth and a curve hatched around the eye and the front nostril.

The neck and the cheeks, as well as the area behind the animal's ears, should be

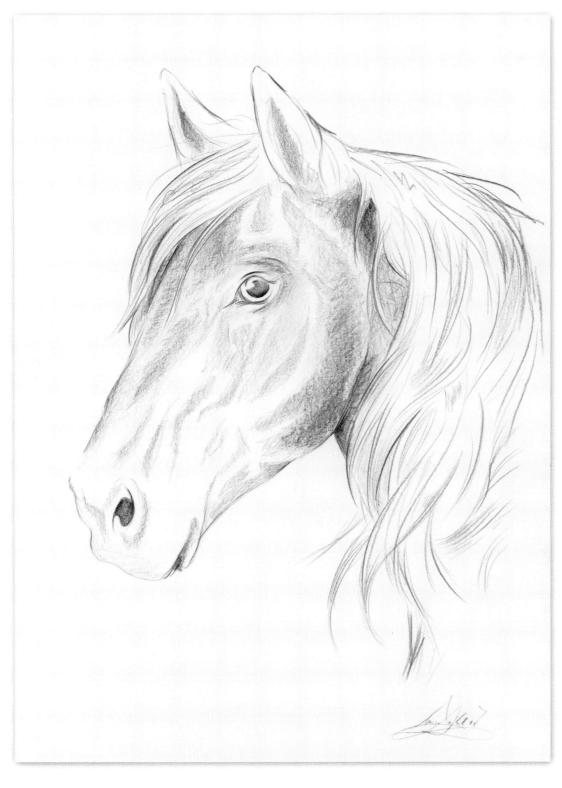

2 Use carefully placed hatching to give the horse's head a three-dimensional appearance.

shaded more strongly to push them back. Now colour in a small area in the ears and intensify the nostrils and eyes of the horse. Work on the mane using some sweeping lines, leaving it largely free of colour. When completed, fix the picture.

Family group

There are few sights more magical than that of a mare with its foal enjoying the freedom of a fine spring day. Watching them interact, you will notice that horses are capable of many emotions, expressions and subtleties, so for your final project it seems appropriate that you should test yourself with this delightful but challenging subject.

Step-by-step practice picture: mare with foal

Materials required
+ *Drawing paper*
+ *6B and HB graphite pencils*
+ *Kneadable eraser*
+ *Fixative*

1 First draw the basic lines for the mare using the HB graphite pencil. Take care to ensure that the lines are as thin as possible and erase any excess lines immediately before

continuing to draw. As the foal covers part of the belly of the mare, you do not need to draw in these lines. Take care to draw the mare's neck with a slight curve and ensure that the mane only falls down on one side. This will emphasise the nice shape of the neck even more. Now add the foal, working with thin lines here too and immediately improving on areas that are not neat or correctly placed. The foal's mouth is covered by the mare's ear. As the mare's legs are partially visible behind the foal, you should make sure that the transition from the legs to the body of the mare is a flowing one, otherwise the legs will look unattached. Draw in both horses' eyes using the HB graphite pencil by first drawing two short lines and then placing a little dot between them. Leave a little glint of light in the eye free of colour. Finally, the ground, on which the horses

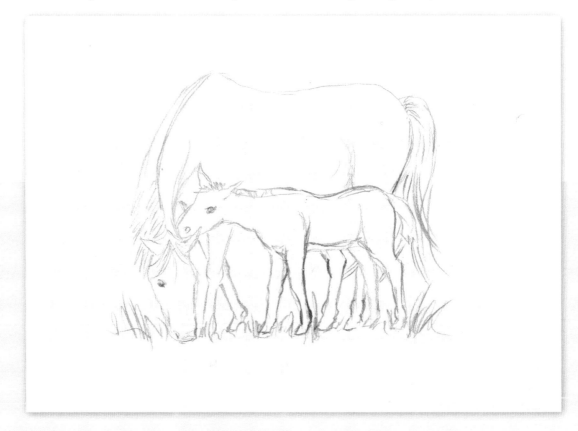

1 Set out the basic contours using very thin lines of the HB pencil.

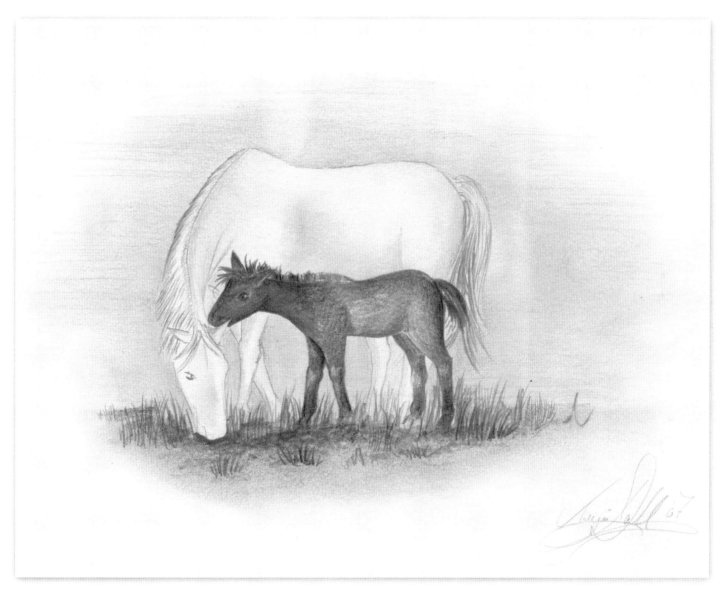

are standing, should be indicated with some blades of grass.

2 Now pick up the 6B graphite pencil. Colour in the foal using an even shade of light grey and then darken it with shading on the legs and back. Use the HB graphite pencil to go over the contours of the foal. Shade over these fine lines too towards the middle of the body, so that there is a fine transition and the outline is no longer obvious. Now hatch the mare quite subtly along the contours with a very light shade of grey using the HB graphite pencil and smudge the shading carefully with your fingers. Darken the background in the same way so that the white mare stands out and appears three-dimensional. Shade the ground more strongly with the 6B graphite pencil and smudge this with your fingers too. Finally, draw some fine blades of grass on the ground with the HB graphite pencil, as well as strands of hair on the tail and mane of the animals. Fix the finished picture.

2 Develop the tones of the picture. For even shading on the mare, hatch lightly using the HB graphite pencil and then smudge with your fingers.

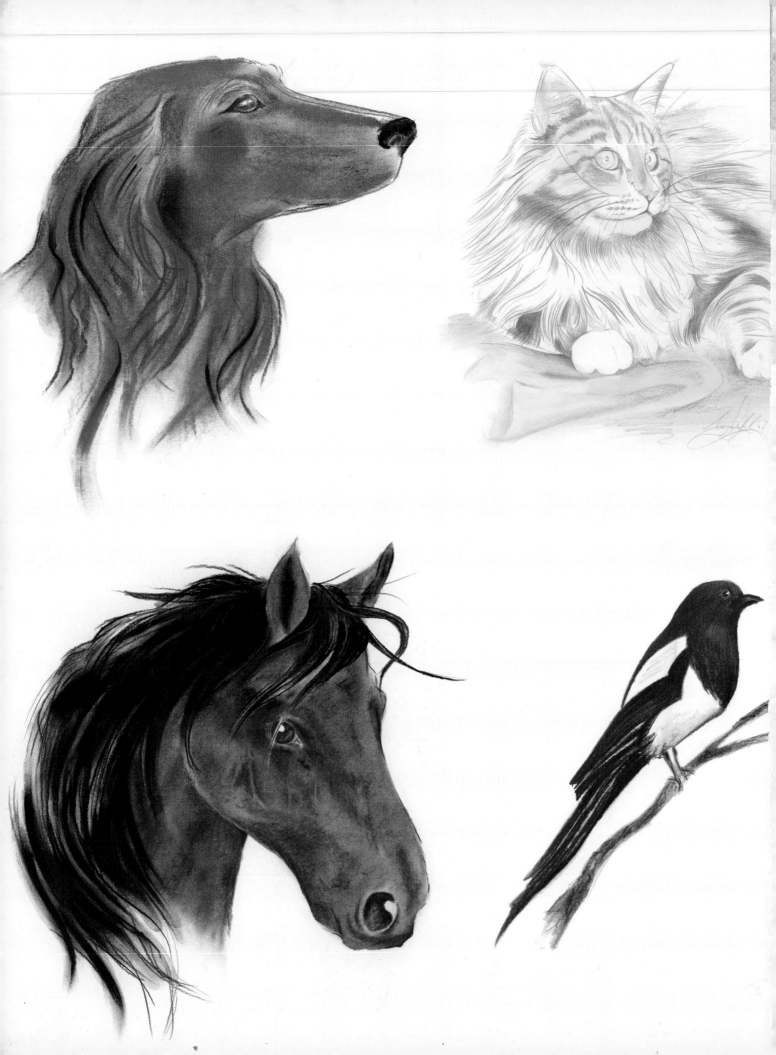